Produced by the Department of Publications,
The Museum of Modern Art, New York

11 West 53 Street
New York, NY 10019-5497
www.moma.org

Christopher Hudson, Publisher
Chul R. Kim, Associate Publisher
David Frankel, Editorial Director
Marc Sapir, Production Director

FORDFOUNDATION

The MoMA exhibition *One-Way Ticket: Jacob Lawrence's Migration Series and Other Visions of the Great Movement North* and accompanying initiatives are made possible by the Ford Foundation.

Major support is provided by The Museum of Modern Art's Research and Scholarly Publications endowment established through the generosity of The Andrew W. Mellon Foundation, the Edward John Noble Foundation, Mr. and Mrs. Perry R. Bass, and the National Endowment for the Humanities' Challenge Grant Program.

Generous funding is provided by Edith Cooper and Robert Taylor, GS Gives; The Friends of Education of The Museum of Modern Art; Marie-Josée and Henry Kravis; Sue and Edgar Wachenheim III; MoMA's Wallis Annenberg Fund for Innovation in Contemporary Art through the Annenberg Foundation; Bernard Lumpkin and Carmine Boccuzzi; Karole Dill Barkley and Eric J. Barkley; and the MoMA Annual Exhibition Fund.

Special thanks to The Jacob and Gwendolyn Knight Lawrence Foundation.

This book is dedicated to the memory of Walter Dean Myers.

Edited by Chul R. Kim and Emily Hall
 with the generous participation of Leah Dickerman,
 Cari Frisch, Elizabeth Margulies, Jodi Roberts,
 Amanda Washburn, and Wendy Woon
Designed by Catarina Tsang, Tsang Seymour Design,
 and Gina Rossi
Production by Chul R. Kim and Hannah Kim
Printed in Korea by Taeshin Inpack Co. Ltd.
This book is typeset in A Gothic, Ionic, and
Clarendon BT. The paper is 150 gsm Snow White.

First edition 2015
© 2015 The Museum of Modern Art
Illustrations © 2015 Christopher Myers

Artwork by Jacob Lawrence © 2015 The Jacob and
Gwendolyn Knight Lawrence Foundation, Seattle/
Artists Rights Society (ARS), New York

Library of Congress Control Number: 2015934888
ISBN: 978-0-87070-965-4

Distributed in the United States and Canada by
Abrams Books for Young Readers, an imprint of
ABRAMS, New York

Distributed outside the United States and Canada by
Thames & Hudson Ltd

Printed in Korea

JAKE MAKES A WORLD

Jacob Lawrence, a Young Artist in Harlem

Sharifa Rhodes-Pitts

Illustrated by
Christopher Myers

The Museum of Modern Art, New York

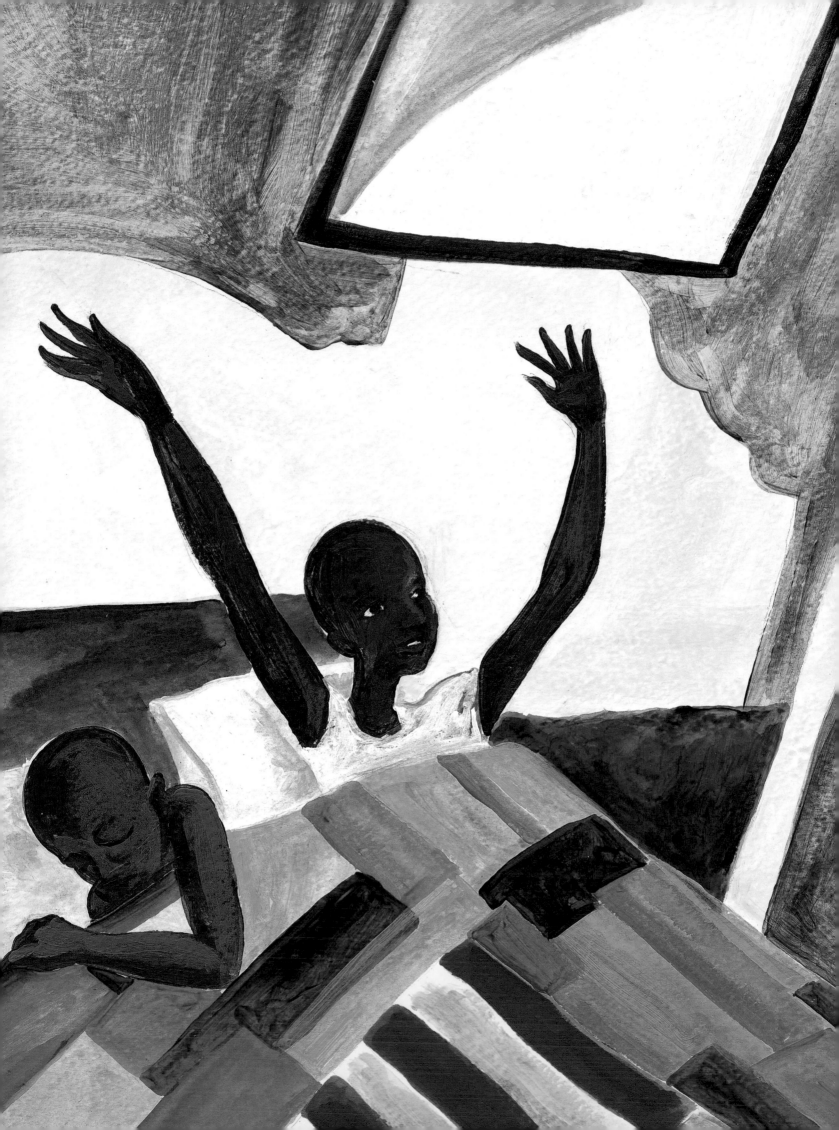

In the morning Jake watches the sun wake up.
He makes a big stretch, and the sun stretches, too.

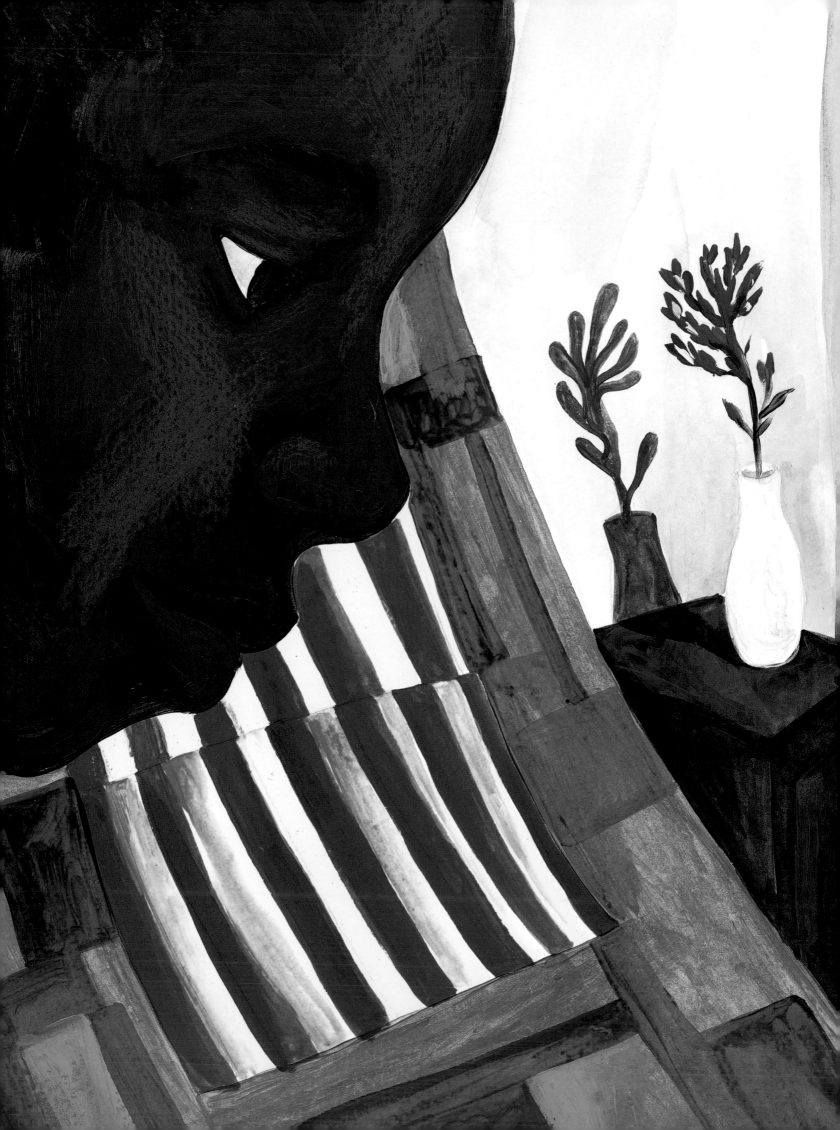

With first light, the dancing dark shadows begin to fade. Then the colors come again.

Yellow, orange, and blue on the quilt that covers Jake and his brother in bed. Mother's paper flowers in pink and red.

His feet sink deep into the thick blue rug. When his toes touch the ground, it's like a sky upside down.

When Jake moved to this new city, this New York, to this neighborhood called Harlem to live with Mother again, these familiar things from his old home in Philadelphia greeted him like long-lost friends.

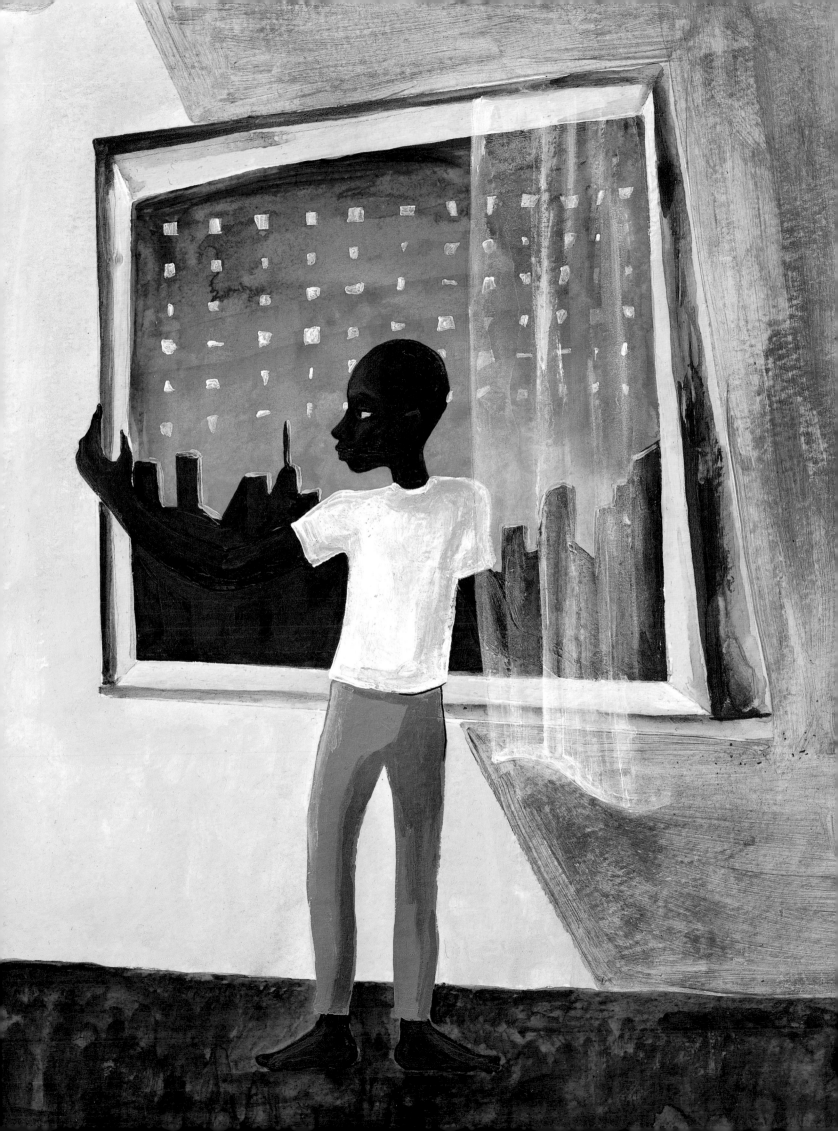

Outside Jake's building, men play chess and checkers, balancing the boards on their knees.

Older boys sell fruit
from a wagon or
ice from a bucket,
shouting for people
to come down and
get it.

Mothers walk fast to work and more work.
Signs promise home-cooked meals for fifteen cents
and a shoeshine to make you brand-new.

Most days after school, Jake goes to
a place called Utopia Children's House.
The word "utopia" means that it is a
special place, unlike any other.
For Jake, it is.

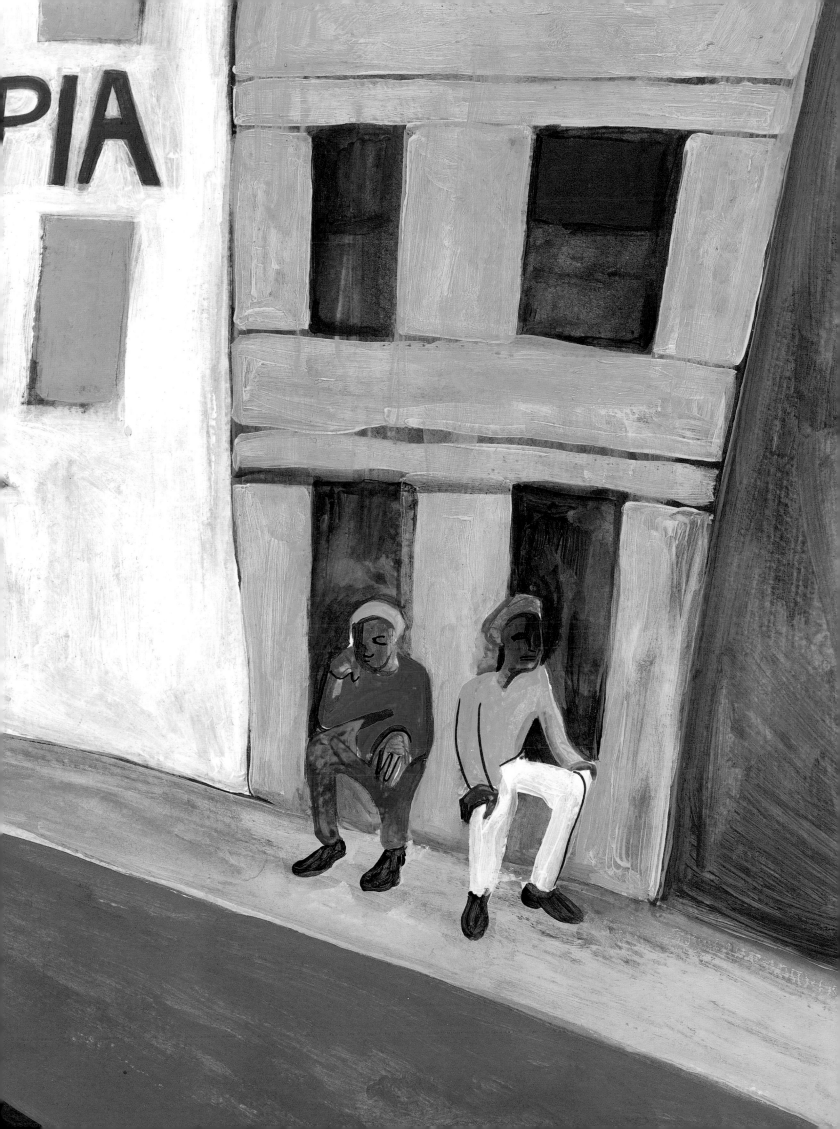

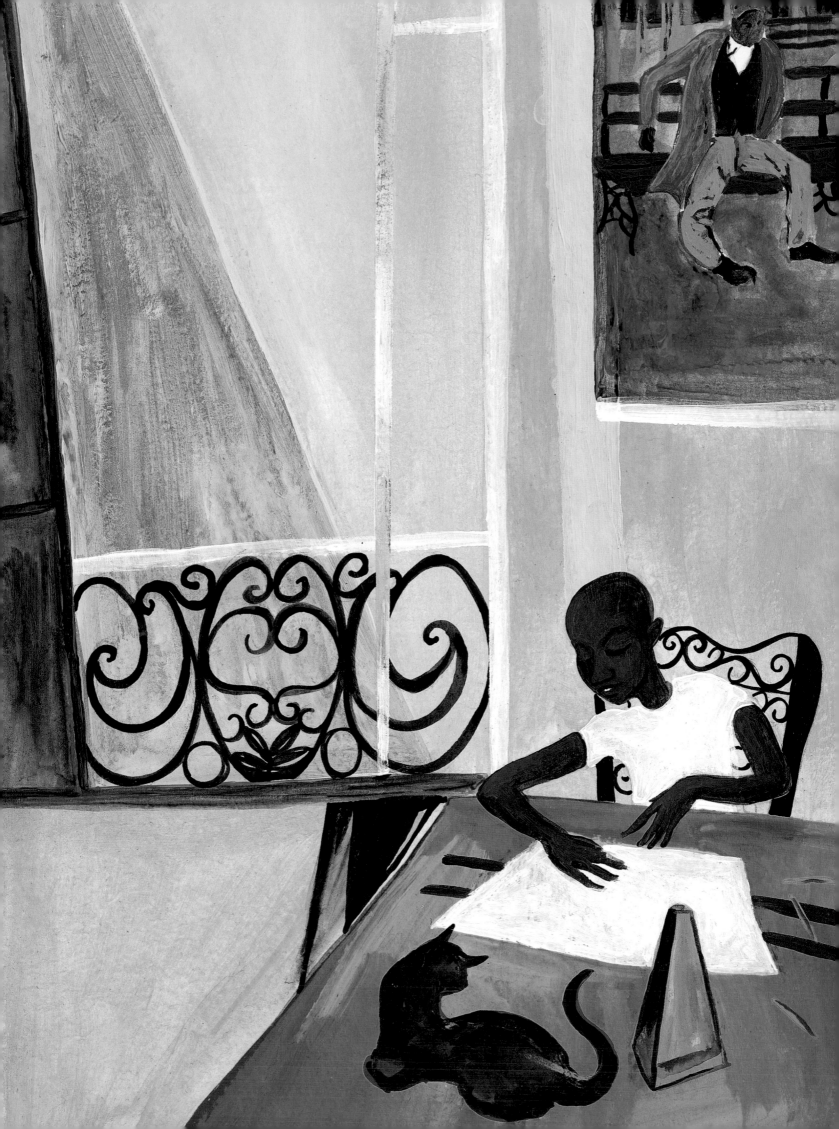

At Utopia House, Jake makes things with his hands. He carves a block of soap into a fish. He sews scraps of leather into a secret pouch. With watercolors he swirls the shadows that dance on his wall at dawn and the patterns of the rugs in his living room.

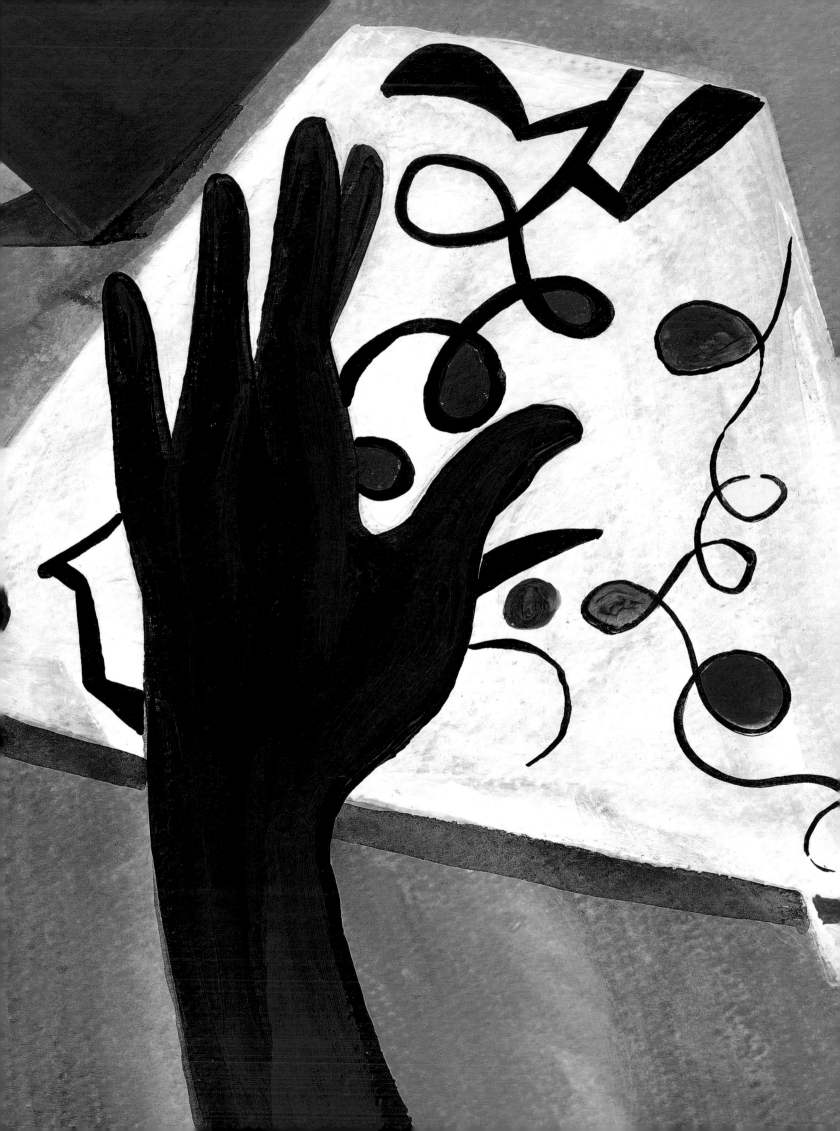

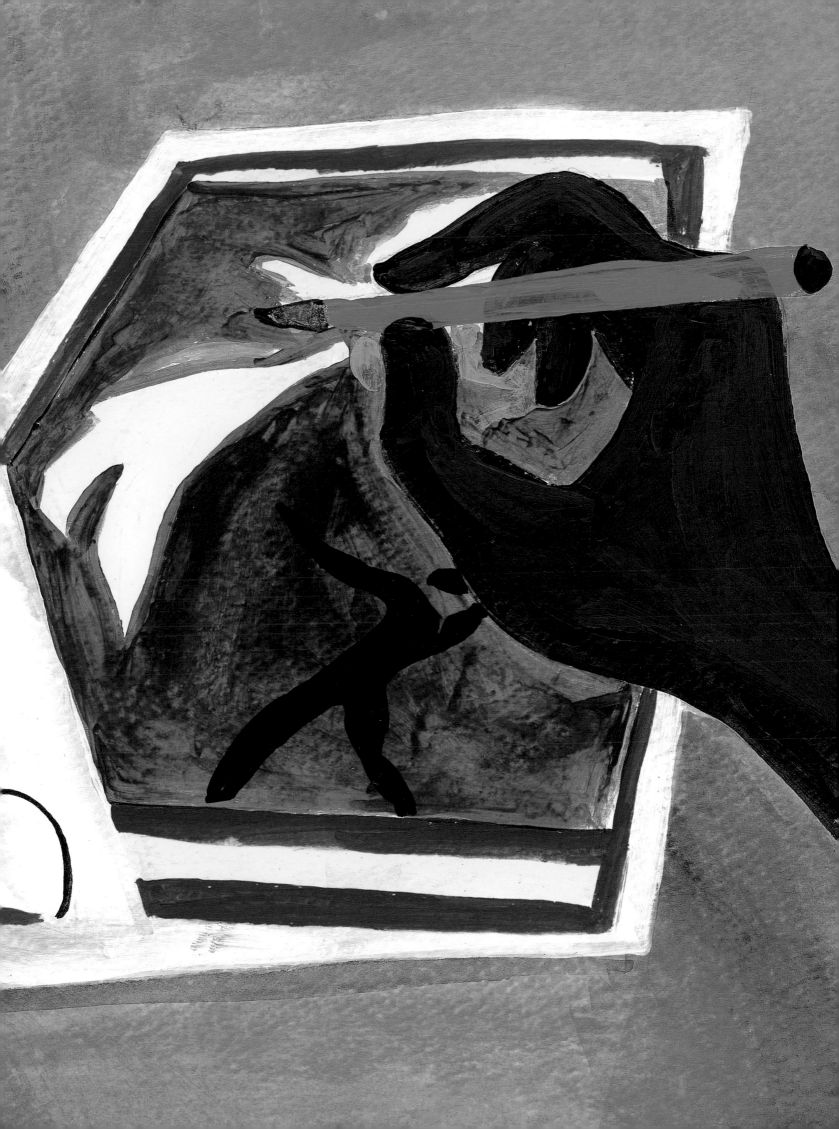

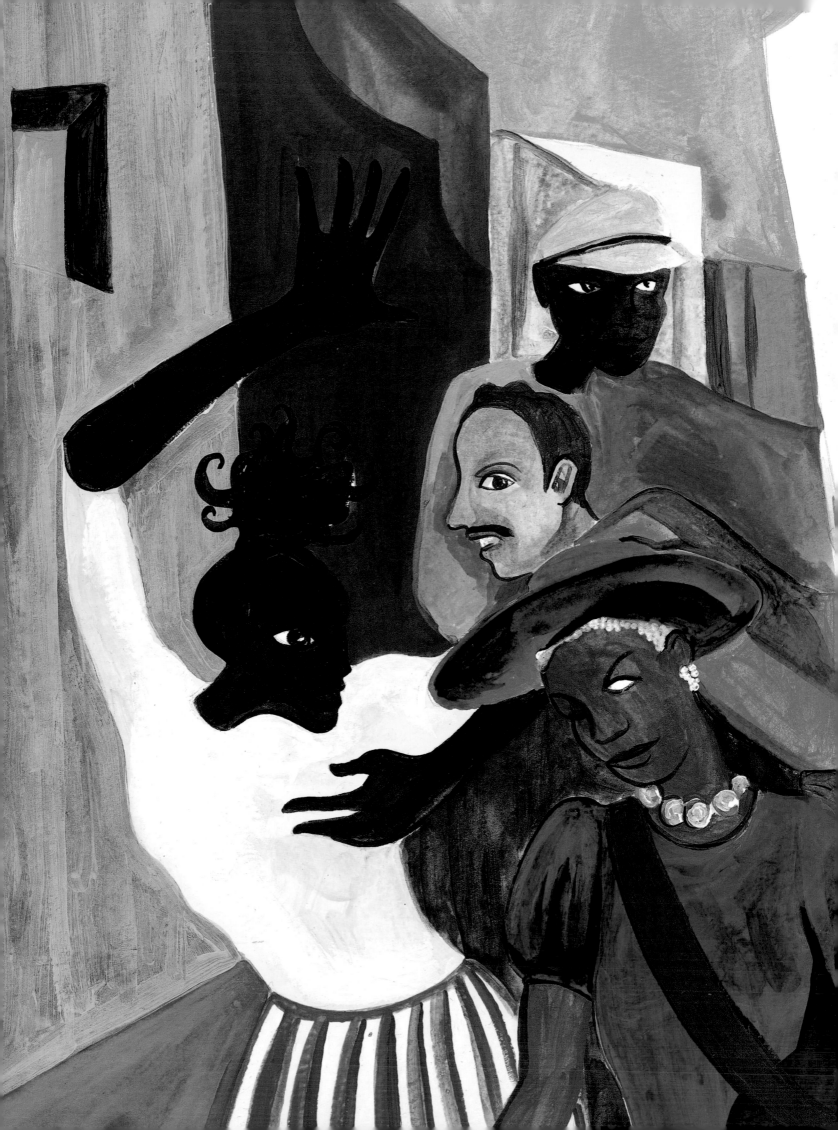

Jake takes a stick of
charcoal and draws
a pair of eyes to
see everything the
people on the street
see. He draws
one pair of ears
to hear all the
shouts and songs,
one mouth to carry
all their voices.
All the faces Jake
sees on the street
become one face.

Jake shows this new face
to his teacher, who
smiles and nods and says,
"You should see this, a
very old mask from Africa."

Jake stares at
the mask for a
long while, and
then he makes his
own mask from
brown paper bags
and glue and paint.
When he is done,
the mask smiles at him.

Next Jake takes a shoebox, and in the box he
tries to fit the whole street. Inside are cardboard
chessmen, tiny boys folded from construction paper,
and mothers walking fast to work, wearing dresses
cut from magazines. He stacks matchboxes to make
buildings and paves the street with sandpaper.

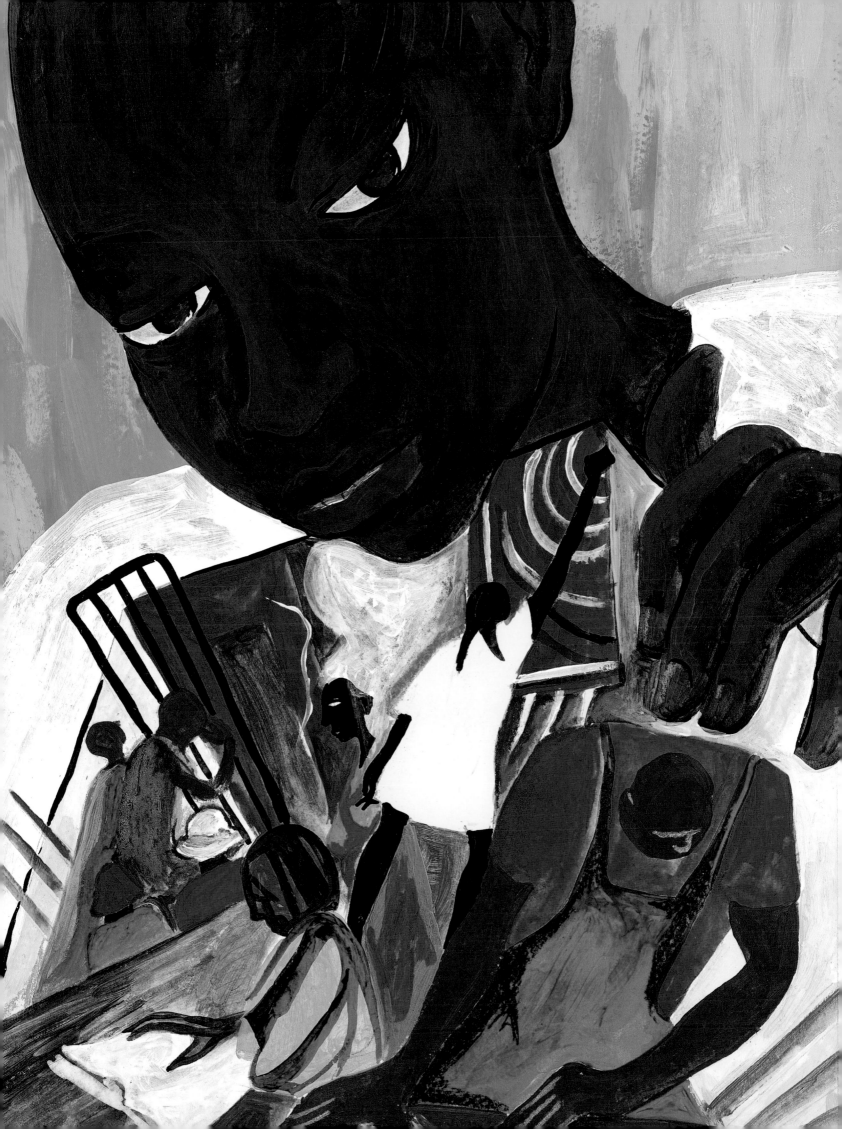

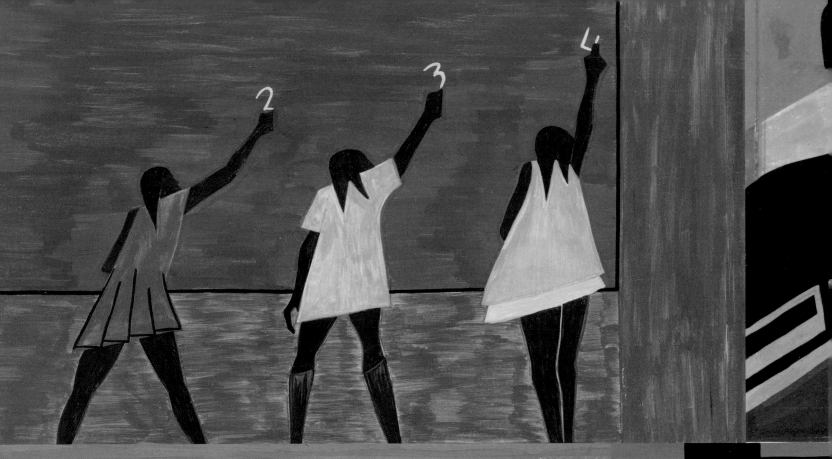

Jake has made a world, a small piece of this place called Harlem. It is now his home.

Jake's Harlem has all the shouts and songs and noises of the Harlem outside, but here they are not sounds. They are colors, they are shadows dancing, they are rhythms, they are light.

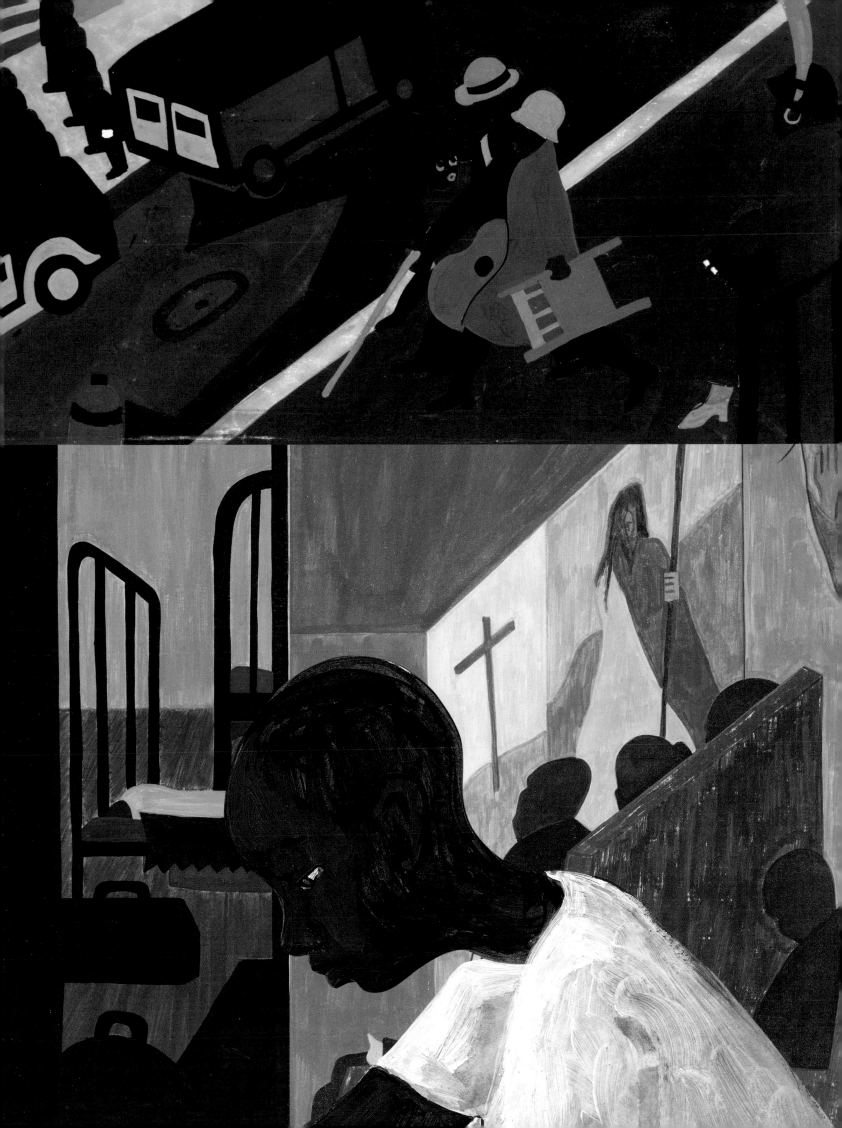

Jacob Lawrence (1917–2000)

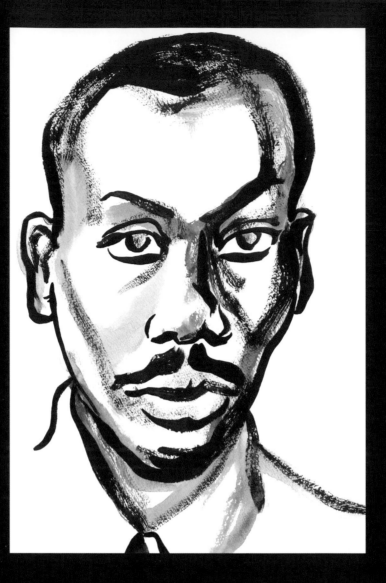

In 1930, when Jacob Lawrence—known to his friends and family as Jake—was thirteen years old, he moved to the neighborhood of Harlem in New York City. His mother had moved there three years before, and, like many children of that era, Jake and his sister and brother had stayed behind in Philadelphia while she looked for work. It was a time of great political and artistic activity in Harlem: the cultural achievements of the Harlem Renaissance had made the neighborhood a gathering place for black artists, and even during the Great Depression there were opportunities for a creative young person to thrive. Jake began taking art lessons, and his talent was immediately evident; his teacher, the artist Charles Henry Alston, said of him that "this was a kid to leave alone

Don't let him start painting like you, don't start cramming him with classical ideas about art or showing him the great. Let him go. Just give him materials." Jake was a young man when he began to imagine a series of paintings about the Great Migration of black Americans who had left the rural South and come to New York and other northern cities. Although the movement was still a recent memory, he understood its importance to American history. By the time he finished the sixty small paintings that comprise The Migration Series, Jacob Lawrence had made a world, bridging the memories and everyday stories of daily life with the unique vision—colors, shape, rhythm, gesture—that marked the rest of his long career.

Works by Jacob Lawrence

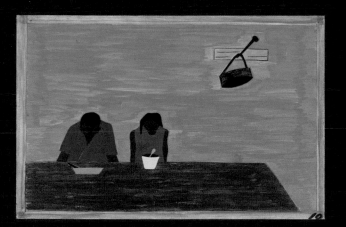

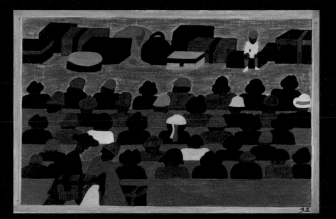

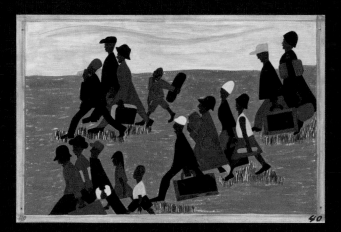

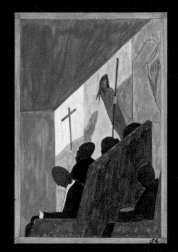

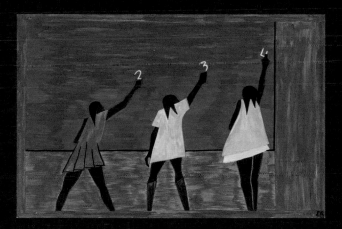

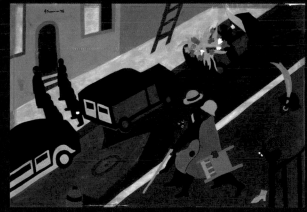

Panel 10: "They were very poor."

Panel 32: "The railroad stations in the South were crowded with people leaving for the North."

Panel 40: "The migrants arrived in great numbers."

Panel 48: "Housing for the Negroes was a very difficult problem."

Panel 54: "One of the main forms of social and recreational activities in which the migrants indulged occurred in the church."

Panel 58: "In the North the Negro had better educational facilities."

The sixty panels in The Migration Series are painted in casein tempera on hardboard. Each measures approximately 18 × 12 in. (45.7 × 30.5 cm). The even-numbered panels are in the collection of The Museum of Modern Art, New York, gift of Mrs. David M. Levy. The odd-numbered works are in the collection of The Phillips Collection, Washington, D.C., acquired 1942.

Bottom right: Jacob Lawrence. *Dust to Dust (The Funeral)*. 1938. Tempera on paper, approx. 12½ × 18¼ in. (31.75 × 47 cm). The Jacob and Gwendolyn Knight Lawrence Collection